IN THE
WILDS

Published by
Princeton Architectural Press
37 East Seventh Street
New York, New York 10003

For a free catalog of books, call 1.800.722.6657.
Visit our web site at www.papress.com.

A version of the drawing on page 25 appeared in
Hawkins\Brown's *Issue 6*, 2008.

Editor: Linda Lee
Designer: Deb Wood
Layout: Bree Anne Apperley

Special thanks to: Sara Bader, Nicola Bednarek Brower,
Janet Behning, Fannie Bushin, Megan Carey, Becca Casbon,
Carina Cha, Thomas Cho, Penny (Yuen Pik) Chu,
Russell Fernandez, Jan Haux, John Myers, Katharine Myers,
Margaret Rogalski, Dan Simon, Andrew Stepanian,
Jennifer Thompson, Paul Wagner, and Joseph Weston of
Princeton Architectural Press –Kevin C. Lippert, publisher

Library of congress cataloging-in-publication data
Peake, Nigel, 1981–
 In the Wilds / Drawings by Nigel Peake. – First edition.
 Pages cm
 ISBN 978-1-56898-952-5 (alk. paper)
1. Peake, Nigel, 1981– Themes, motives. 2. Landscapes in art.
I. Title.

NC242.P37A4 2011
741.942–dc22

2010044572

IN THE WILDS

DRAWINGS BY NIGEL PEAKE

PRINCETON ARCHITECTURAL PRESS

I

16

II

42

III

80

IV

114

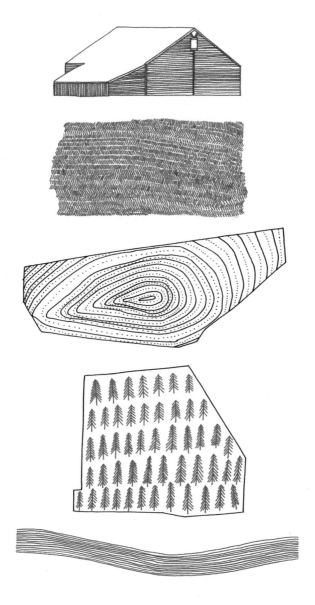

THE LAND IS MADE FROM FIVE PARTS:
SHELTER, MOUNTAIN, GROUND, AND LAKE.

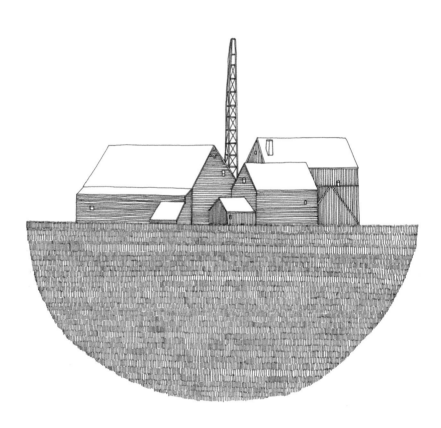

IN THE WILDS

I grew up in a place that nearly every visitor refers to as the "middle of nowhere." I take this as a compliment, but I am not always sure it is intended as such. Open spaces and nature were all that I knew for years. As I grew older I experienced cities, but it was often done with the appreciation of a six-year-old. To this day I find it wonderful to visit cities, to be part of the noises and colors that are resolved in a coordinated jumble—the steel, glass, and concrete that make architects' dreams possible. However, I am always drawn back to the country.

The country may be close to the city edge but can feel a world apart. There are few visual surprises in the city. If there is a surprise to be had, it is probably preplanned. This is not so in places free from the grid. Not that things are less considered; in fact, the opposite might be the case. Concern for fashion and aesthetics seem frivolous; function is the key. Will it work, and will it stand up? Rarely do you see new materials—most are old

and reused, warped, worn, and faded until they just fall into the ground to become a part of it.

When you look around, the day before is present—there is no pretense that each day is new. Roads are not swept clean at night, and buildings rarely demolished. Along the quiet roads, old stone homes of long-gone communities nestle alongside more modern ones. From buildings to everyday things, people from the country are reluctant to be rid of anything, with the belief that it will be useful for something some day: it is typical for old newspapers and cuttings to be stored under the kitchen chairs, and during a conversation, it is with a simple action that the necessary information is retrieved.

With winter winds and driving rain, things naturally fall apart—twisted, gnarled, and eventually incapable of function. When something goes wrong, the solution is often improvised with whatever is available. This haphazard collage of old materials can make it feel as if the country

is in a constant state of disrepair. The fences and gates, in particular, embody this with their bespoke supports. When one part collapses or a hole appears, the ubiquitous blue twine comes out to bind everything together. Sometimes the original structure disappears altogether, and all that remains is the collection of parts propping it up. With this unspoken artistry, the unexpected is made.

When I was growing up, the tallest objects around me were the nearby trees and the distant mountains. The scale of nature is very different from that of built environments; it does not overly concern itself with the human hand. The land is cultivated as fields, and sometimes the bigger rocks are removed from them so that they can then be called gardens.

I used to help out in my neighbor's gardens. My favorite part of this was cutting the grass with a hand mower—especially if it was long and over-grown, thick and entangled with thistles and

daisies. It was during these moments that I could have that wonderful experience of creating a path where none existed before. Back and forth at a slow pace, the mower and I pushed the grass to one direction and then another, filling the field with stripes. When necessary, I would cut back the hedges and trees. The closer I got to the objects, the more I would see their hidden structures and textures—to inspect the twists, twirls, and eruptions involved in a bud on a branch.

The last stage of cutting back trees and branches involves collecting the sticks and debris. Most of the time the discarded branches are stacked and, depending on the type of tree, used for kindling. It is around this warmth—typically in the kitchen—that people gather. During the winter months, the outside walls of buildings disappear under stacked timber, whose profiles reveal countless growth rings and seams. And so, what came from outside becomes the dried logs that enable the flickering flames inside the home.

Daily life in the country did not involve frequent trips to the nearest town for every errand—it was too far away. So some of the necessary parts of the town came to the country—the milk cart, the portable library, the trash lorry, the vegetable van, and the postman. They came on different days, and the names of the week were replaced by the names of their associated portable building. (My sister's first words where "bingo bus," which used to pass by on Monday nights.)

There is a uniqueness to the use of language in the country. Conversations ramble and fade, filled with local sayings and nicknames. Behind the guise of the vernacular, I have known people for years without being familiar with their real names. The nicknames are rarely cruel, usually capturing the person in one word: the local man known for carrying news from one back door to the next is called "Pigeon."

When I was young, I used to complete my homework on a desk looking out onto the opposite road where the portable buildings passed. In between smudged math equations and drawing chemistry experiments, I could see the farmers working in the fields—their hats at impossible angles and days of dirt camouflaging their overalls, the colors of their checked shirts faded and with tears stitched countless times. Like a scarecrow, their clothes seem to hang from their frame—the signs of age making the farmers appear suspicious of anything new.

In the winter the farmers would check on and feed their animals, but when the days would lengthen, there would be a new activity. One of my favorite things during summer evenings was watching the haulage of freshly bailed hay that would continue long into the night—the tractors rumbling and trundling past my window with their light beams tracking along and across the ceiling.

My understanding of the function of these machines was gleaned from observations. In truth, this is how I approach most of the objects drawn in this book. I cannot identify the name of every bird song, type of tree, or field condition, but I do have an appreciation and inherent joy of the things around me.

I normally go for a walk along the country roads once a day, either early in the morning or at dusk. There aren't many choices in the walk: you can walk either to the left or to the right. Along the fields you share the path with animals, all crossing and passing the same obstacles at different speeds and heights. Walking a familiar road is a little like making a drawing, with something new moved and marked each day. You rarely see the larger change take place; it always seems to happen when the head is turned. One moment the tree is bare, and the next, a small leaf has appeared. As if it had always been there. New tracks are pressed along the side of the road

after nighttime rains, bails of hay gathered after harvest, the thrown litter from yesterday now accumulated in the hedge. It is with these small increments that the country changes, retaining these marks as part of its shape.

As you walk a silence washes over you. In the city you have to try and break away from the noise. In the country it is different. It is a distant sound: it might be a single bird singing or perhaps five types of birds calling, talking, and warning. More likely, it is a medley of animal sounds—barks, tweets, grunts, and bleeps. In open spaces, the sounds travel and merge to create an unplanned melody.

Even as a child, there were routines I enjoyed in the way I now appreciate walks. The car trip home from school each day was more or less the same journey. Watching the familiar objects pass by—the red barn, the fallen house, and the field with three horses—I closed my eyes and imagined what I was passing; I did

this for longer and longer, testing my memory of the familiar roads. Sometimes I thought I was home and opened my eyes to find myself only halfway there. I no longer shut my eyes when I am traveling, but drawing is similar to that experience. Reimagining what is outside. Getting lost. To let things wander, to collect, and rearrange. With simple tools I recall and mark these things around me. Drawn again and again, forms and colors take shape. It takes time. It is a joy to make. It is a joy to remember.

THE LAND
IS MADE
FROM
MANY SMALL PARTS

THE HILLS, FLATS AND
VALLEYS MADE UP OF
COLORS AND SHAPES

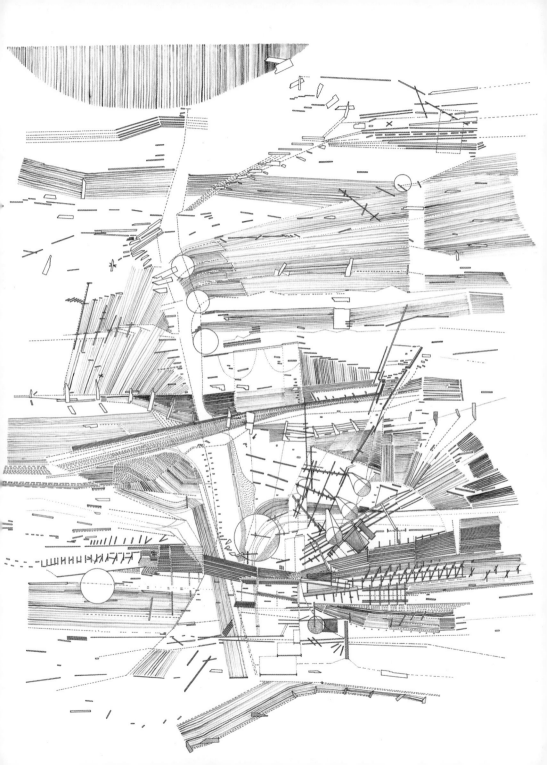

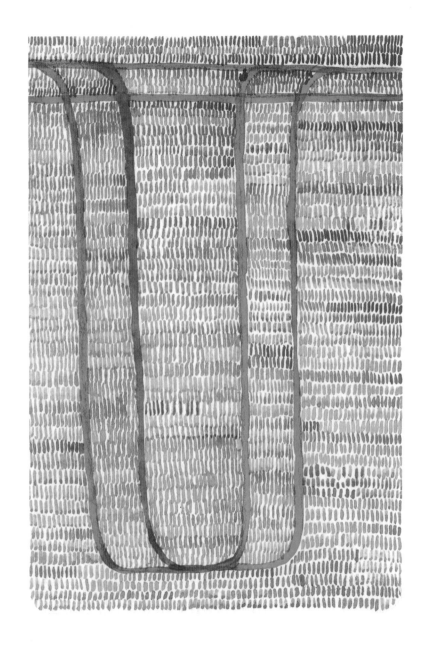

FIELD CONDITIONS (WINTER)

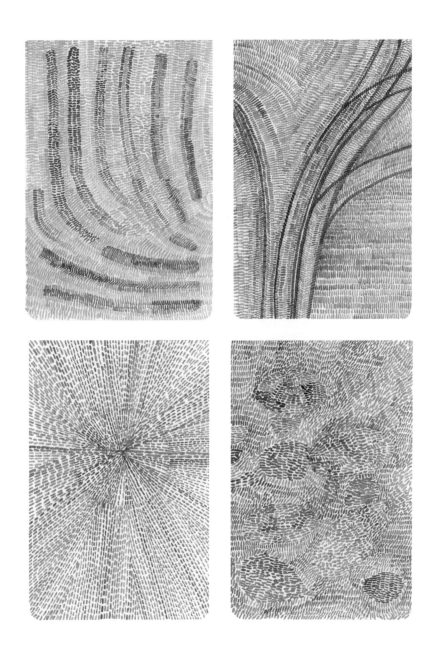

CLOCKWISE FROM TOP LEFT: WORN GROUND, TRAILS, NEW
GROWTH, AND TRACKS GATHERING AT A MEETING POINT

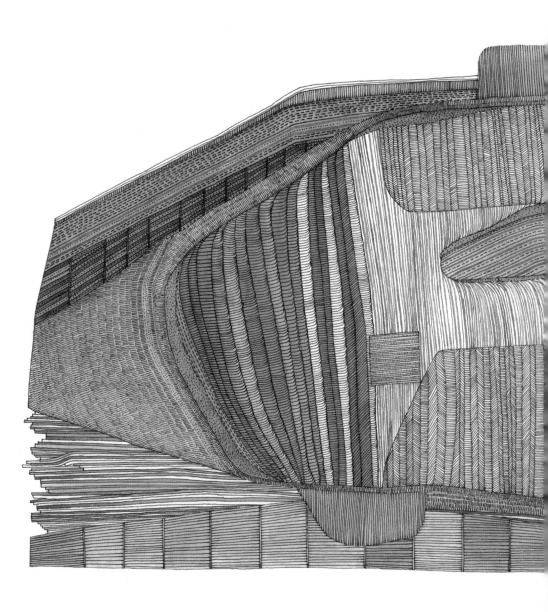

MAN-MADE LAKES AND SMALL ISLANDS, WITH CURRENTS

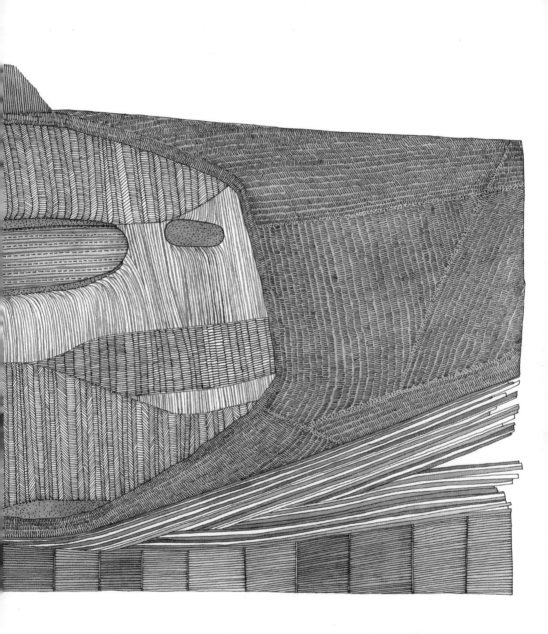

IN BETWEEN THEM THAT SHIFT WITH THE WIND

WHERE THE LAND MEETS THE SEA

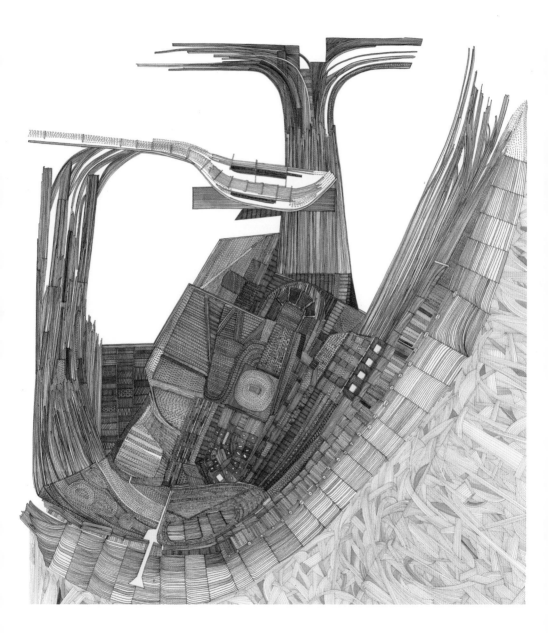

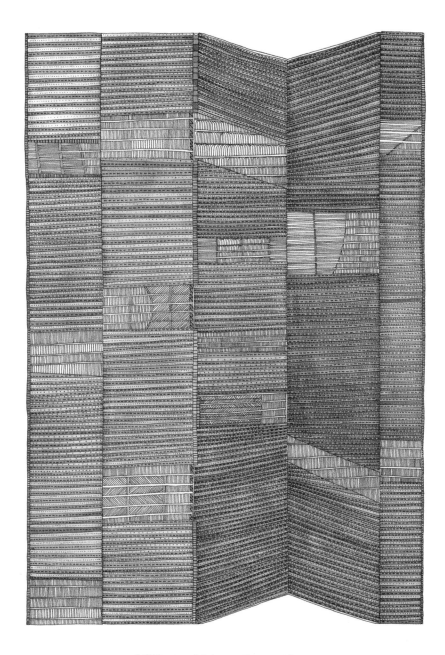

STRUCTURES OF SHELTER

26

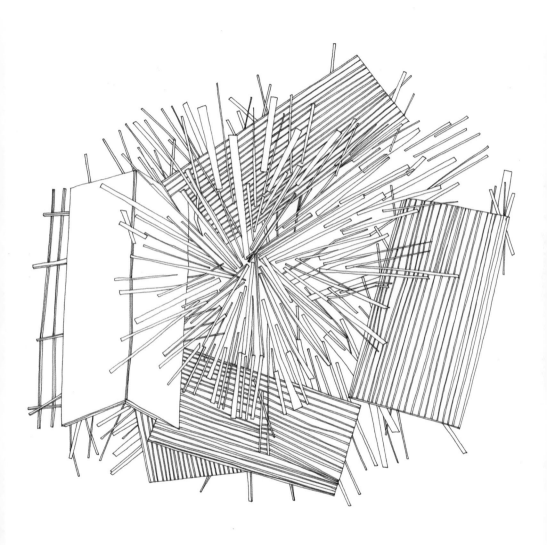

STRUCTURES THAT HAVE FALLEN

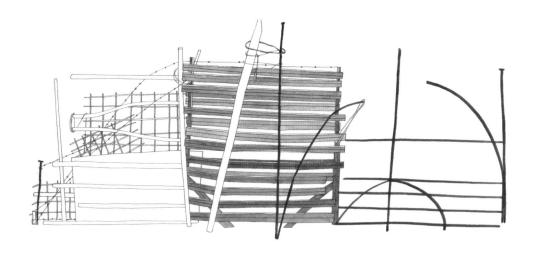

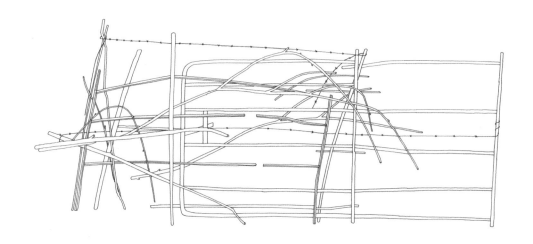

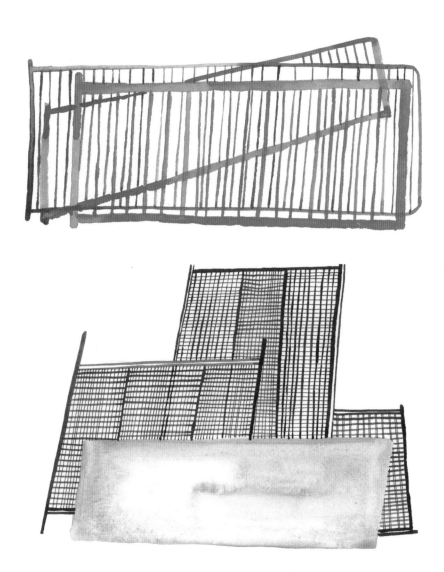

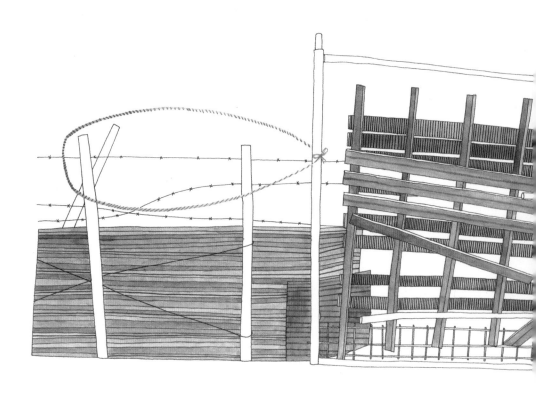

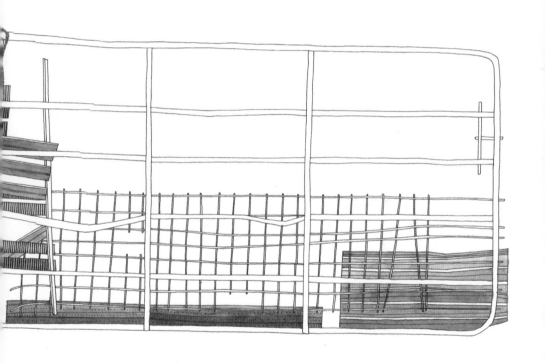

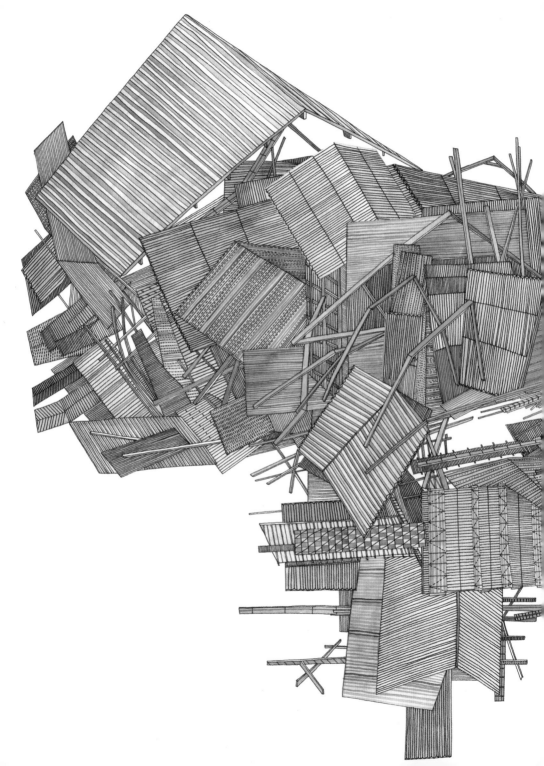

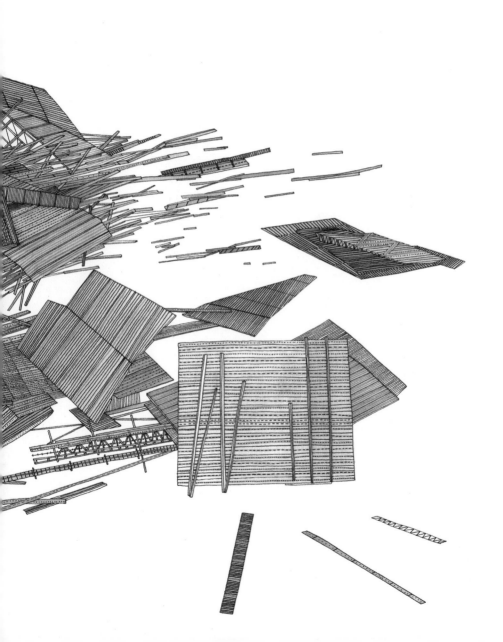

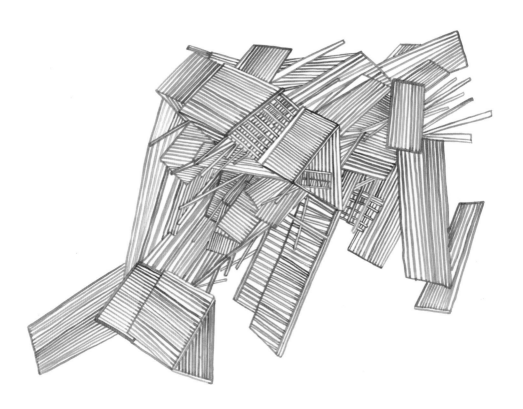

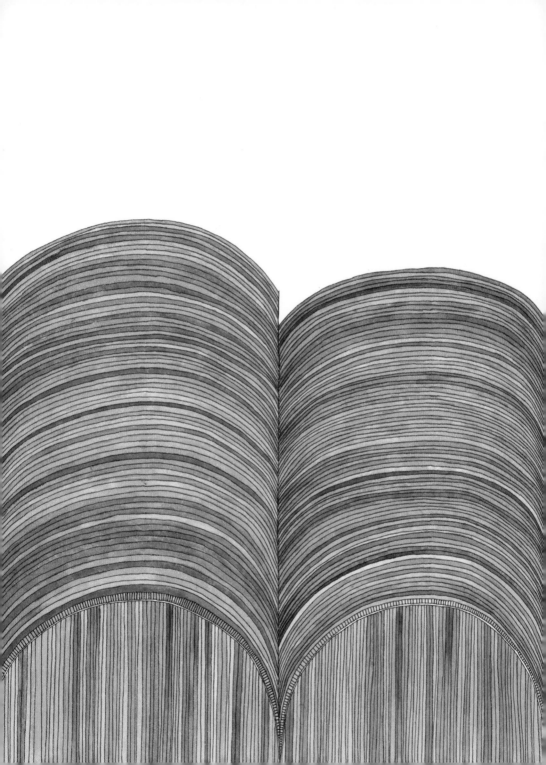

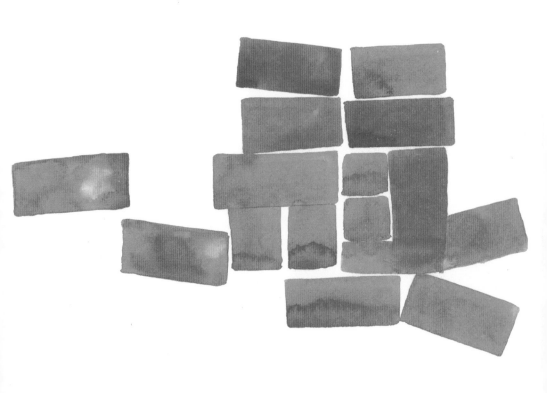

THE REPETITION OF SMALL OBJECTS
(BRICKS) MAKE THE BUILDINGS

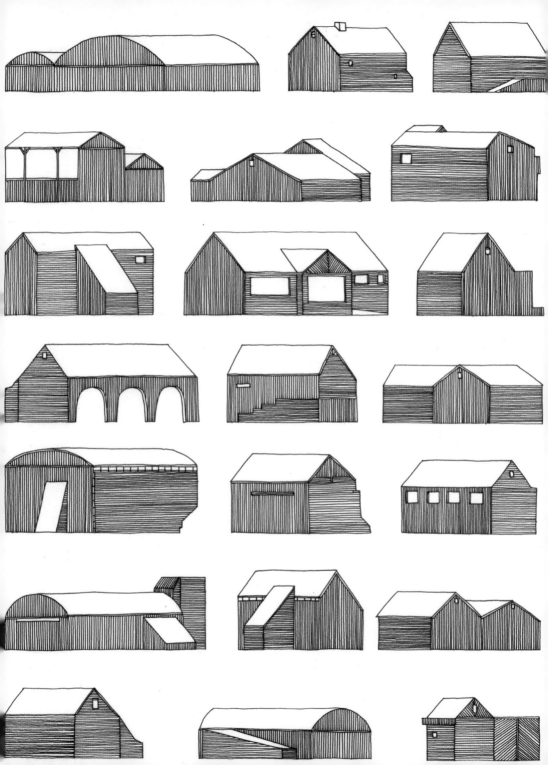

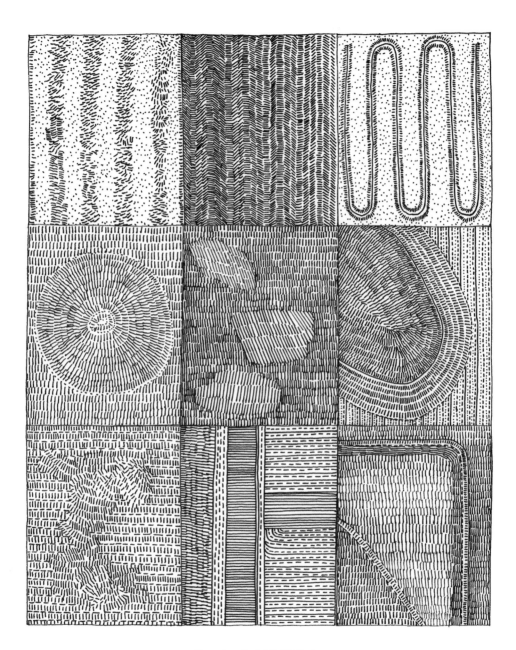

FIELD CONDITION
(SUMMER)

FISHING NETS

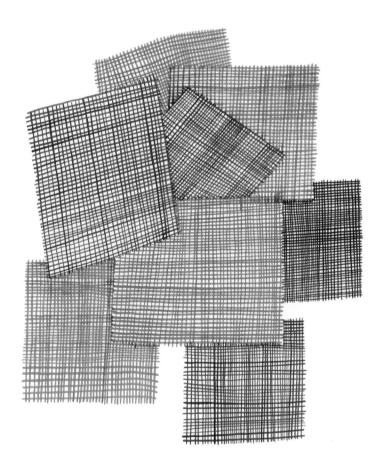

THE BARN STRUCTURE
STANDS ALONE,
SURROUNDED BY DISCARDED
AND ORDERED FRAGMENTS

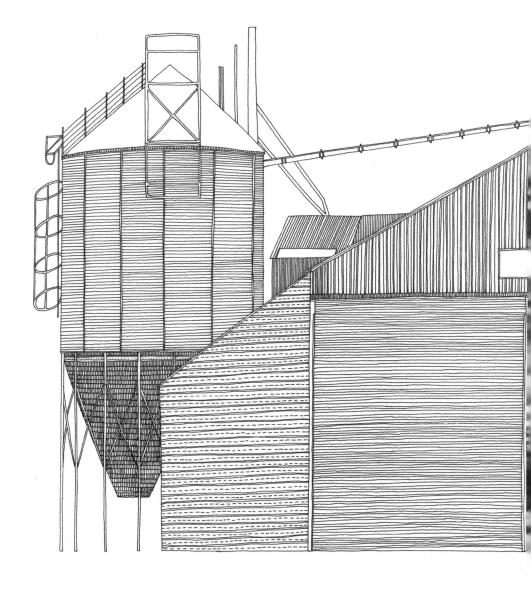

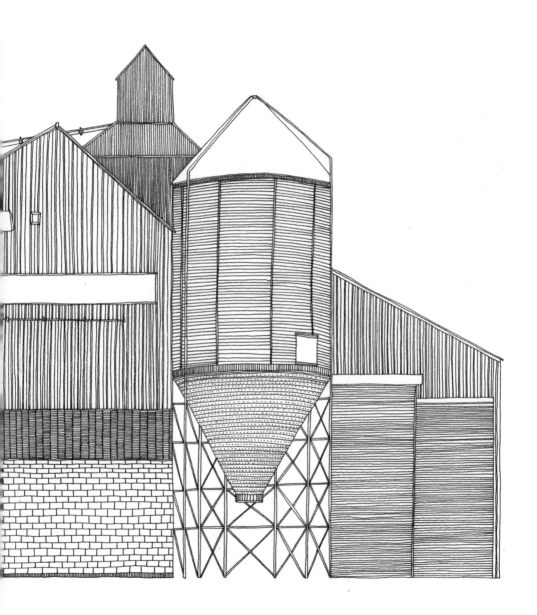

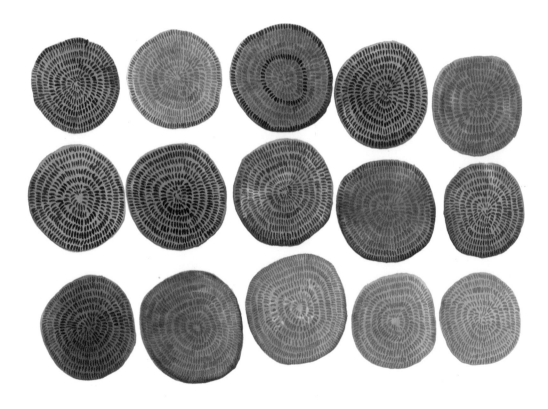

BAILS WRAPPED IN PLASTIC
(FOR WINTER)

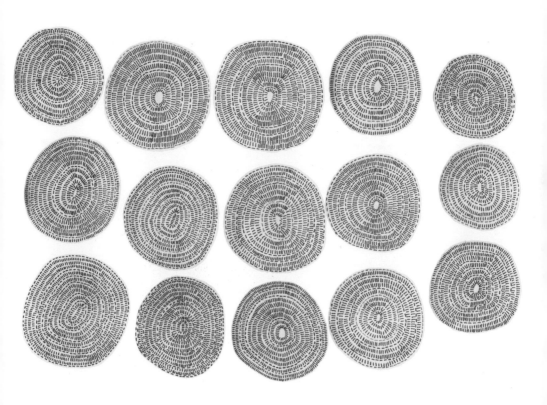

BAILS OF HAY COLLECTED
(END OF SUMMER)

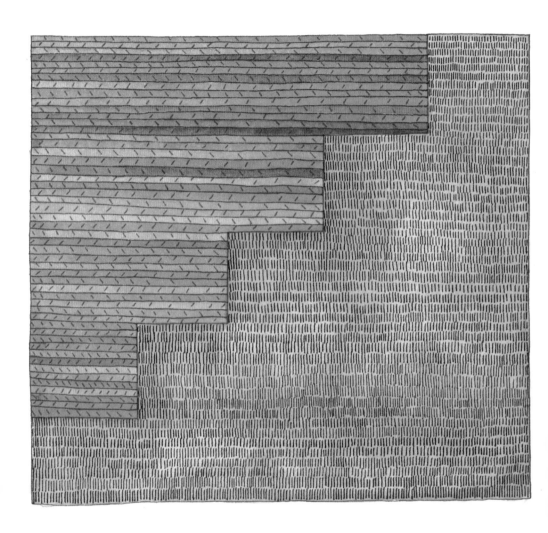

STEPPED END OF A FIELD

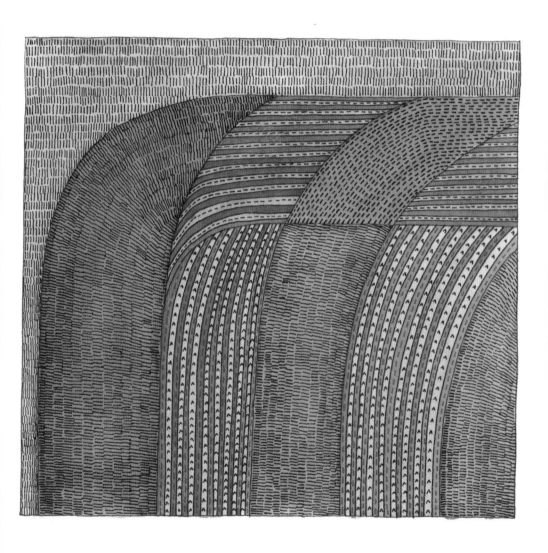

ROUNDED END OF A FIELD

TIRE TRACKS AND LAYERS OF MUD
GATHER AT THE SIDE OF THE YARD.

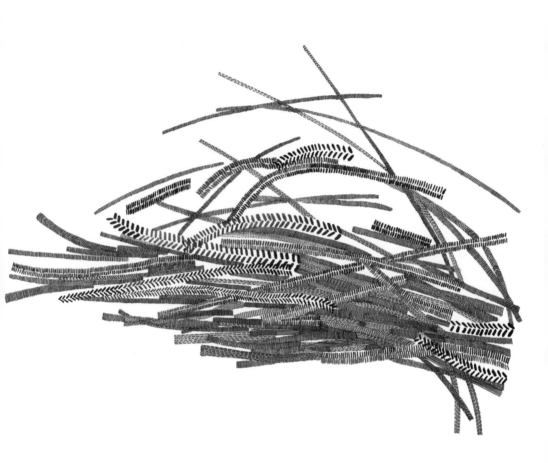

PALLETS STACKED IN YARD

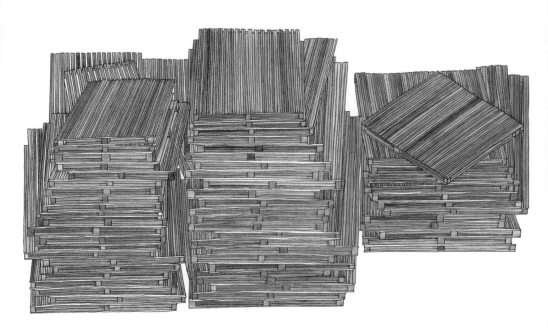

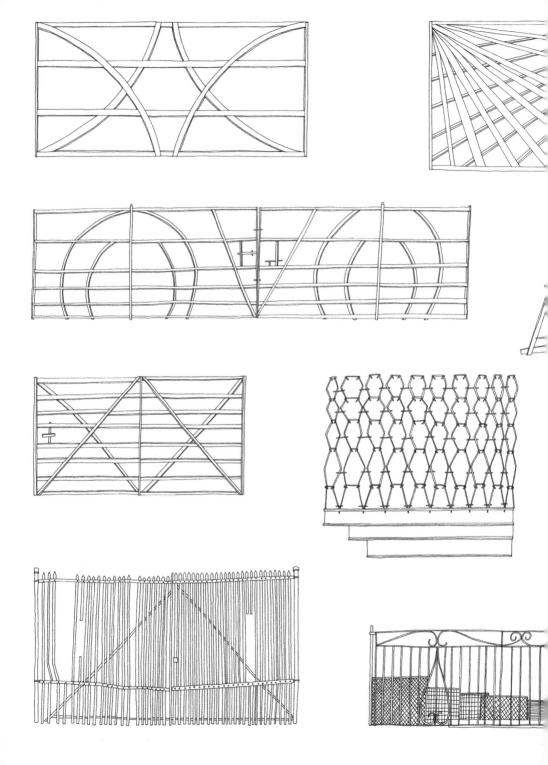

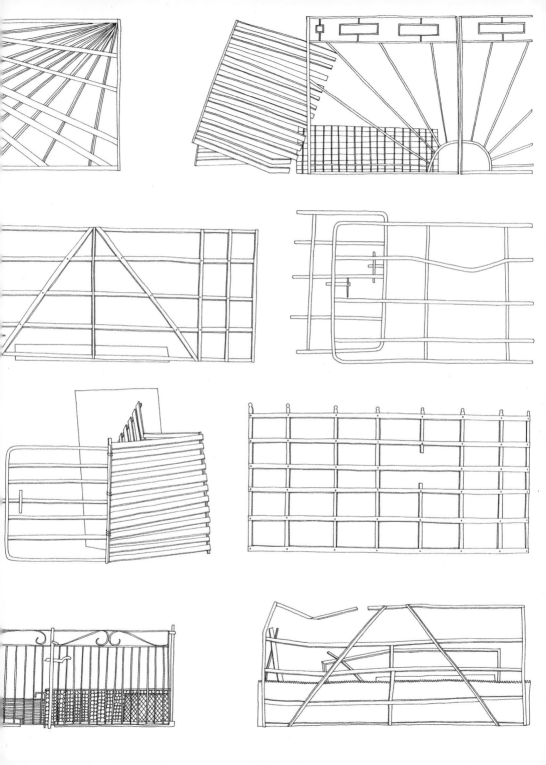

HOW THEY GATHER

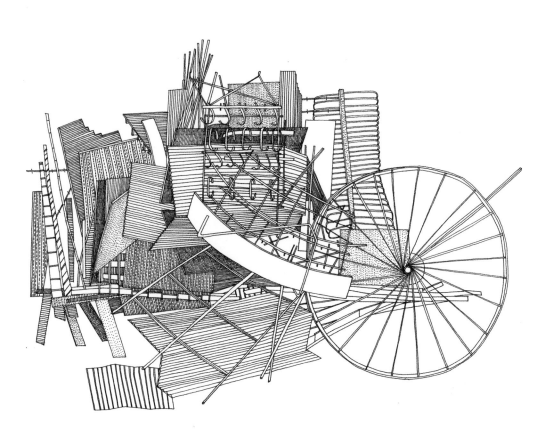

THE CORNER OF THE YARD

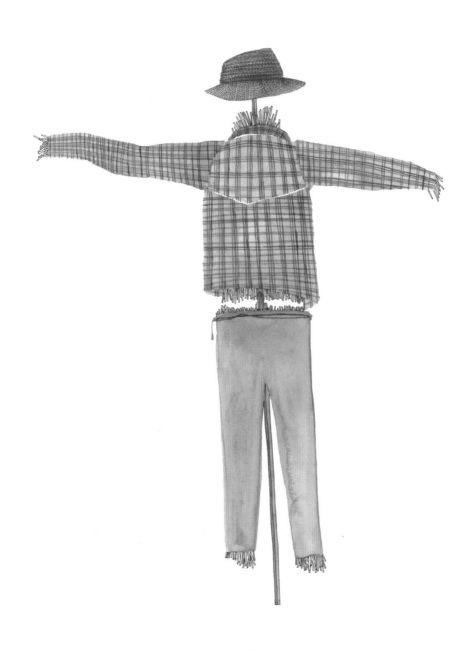

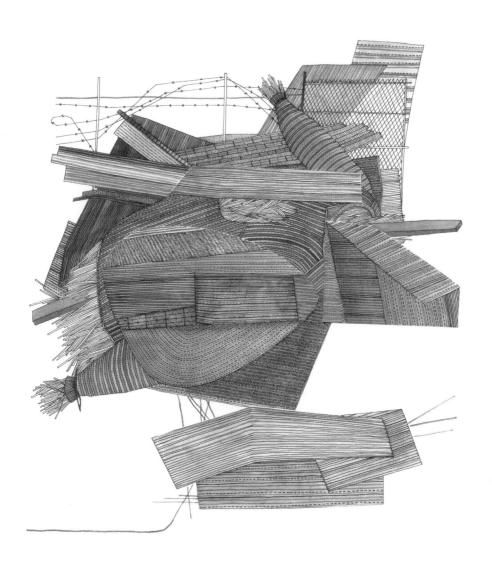

THE FALLEN SCARECROW

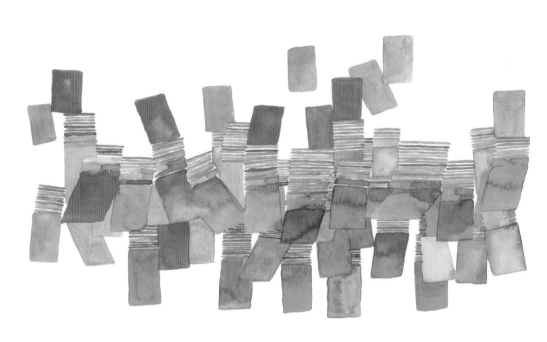

THE ROOFS ARE MADE OF THESE.

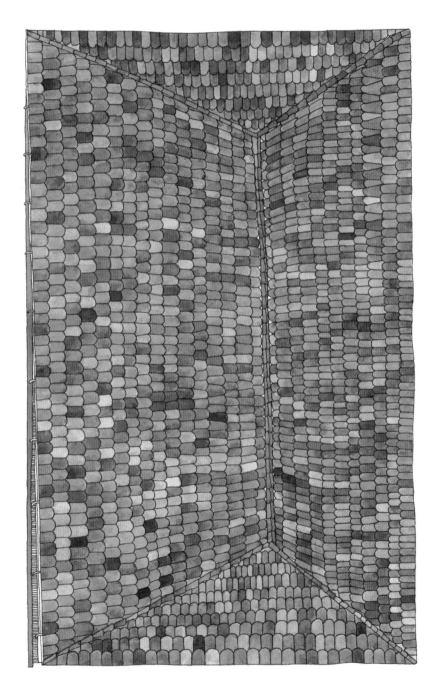

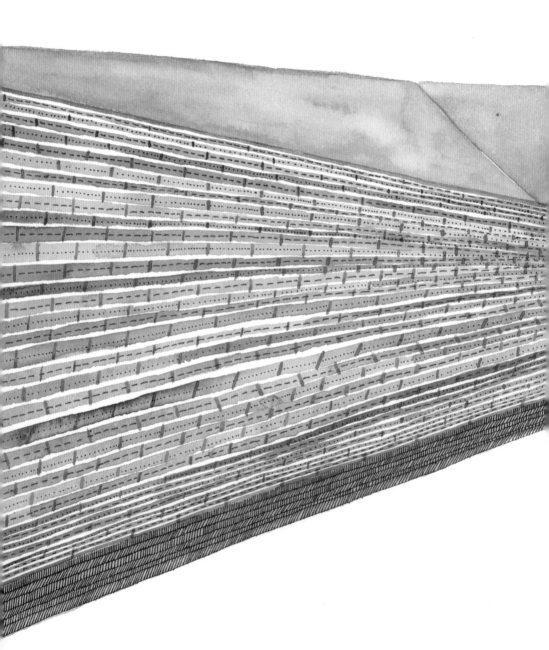

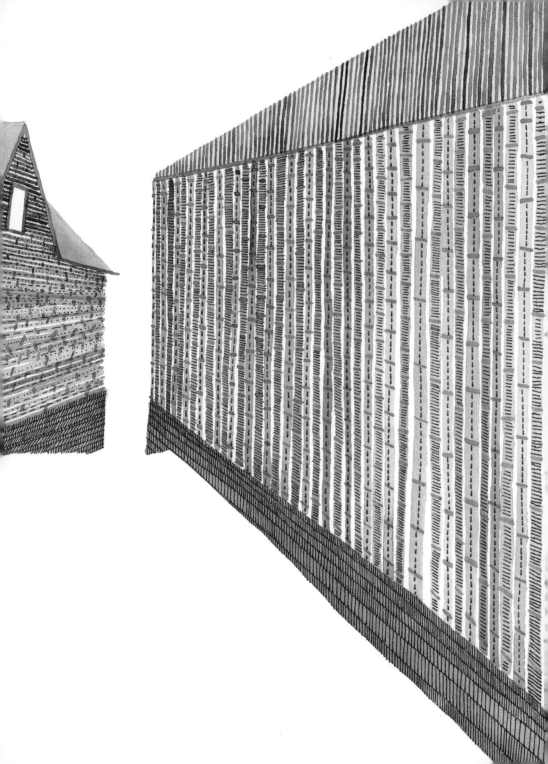

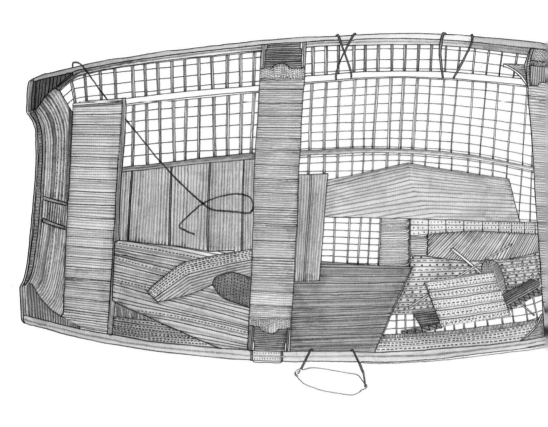

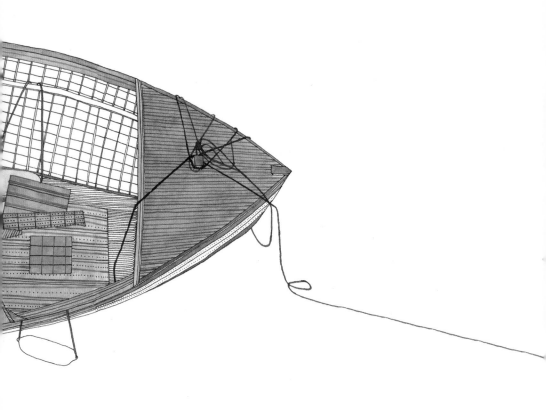

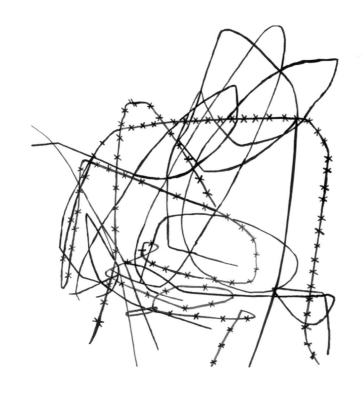

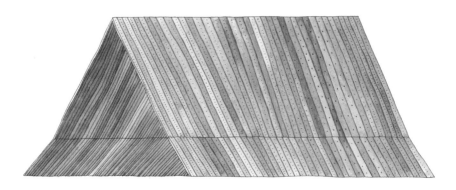

FALLEN SHED

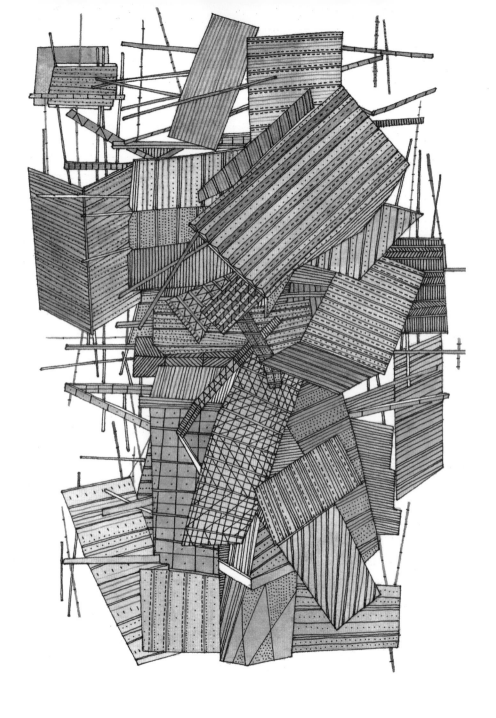

69

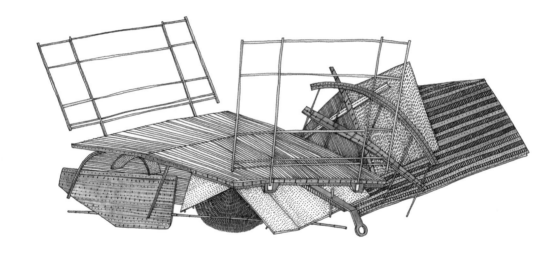

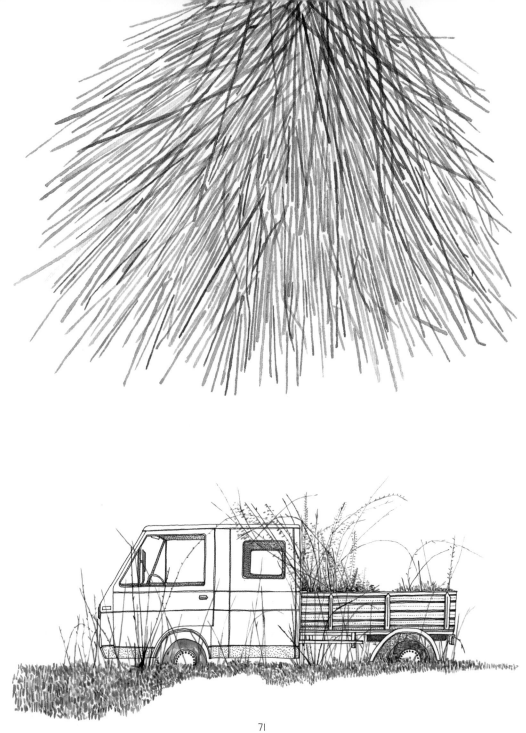

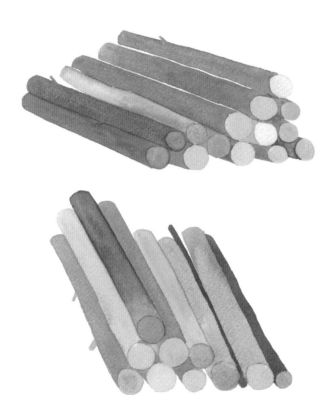

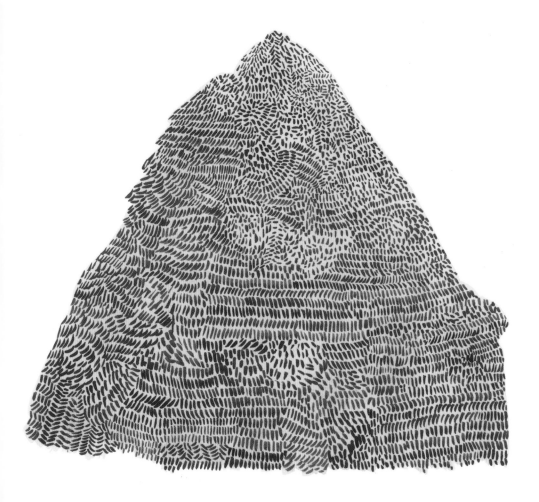

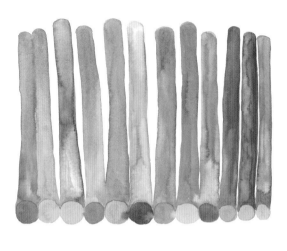

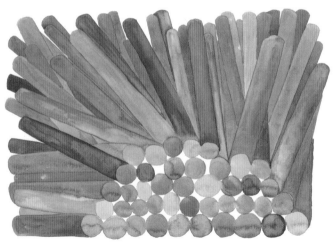

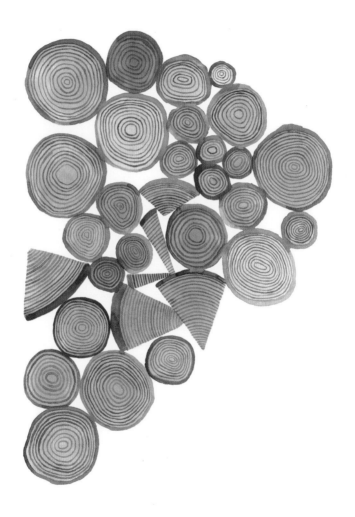

RECTANGULAR BAILS STACKED

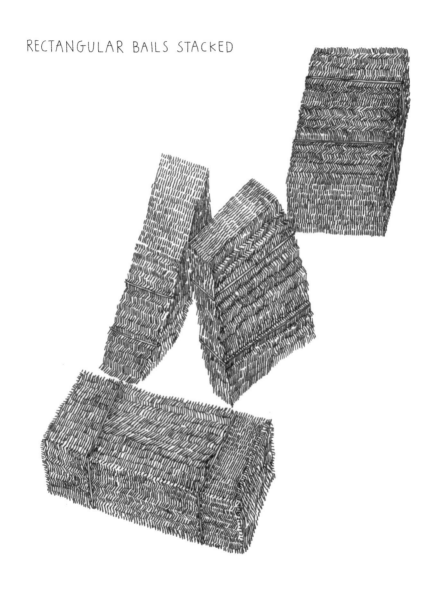

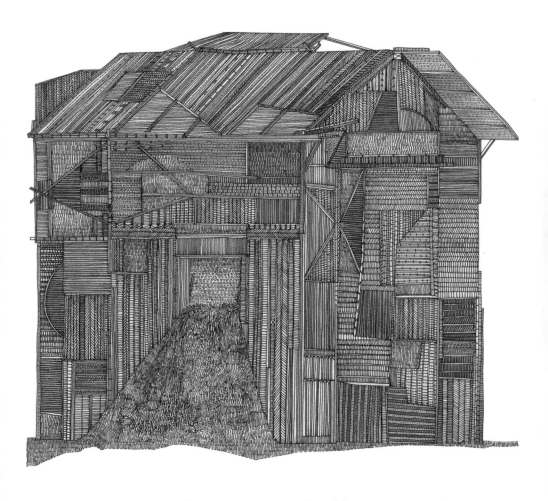

SHED STORING OLD GRAIN

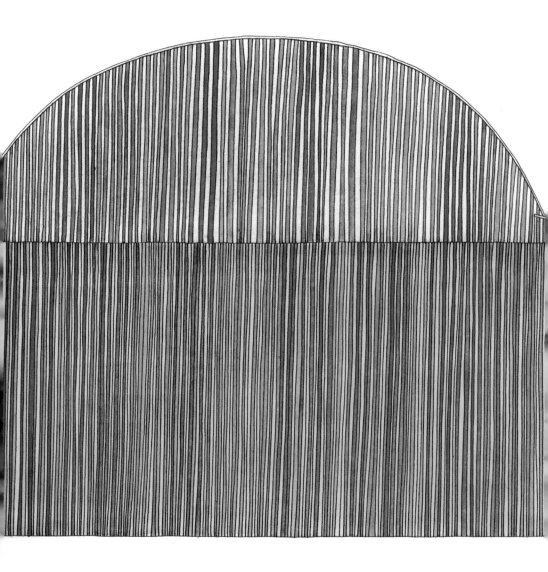

THE FIELD:
THE PATTERNS
AND NATURAL
OCCURRENCES
THAT HAPPEN WITHIN IT

FROM ABOVE, THE FIELDS
FALL INTO PATTERNS.

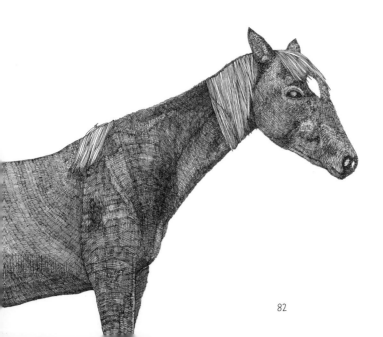

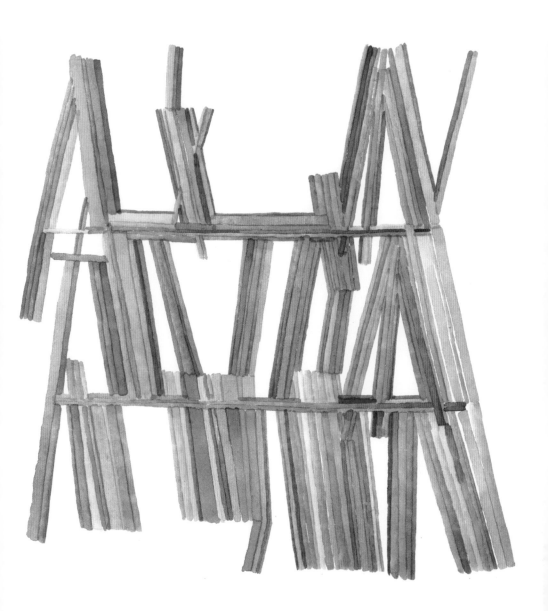

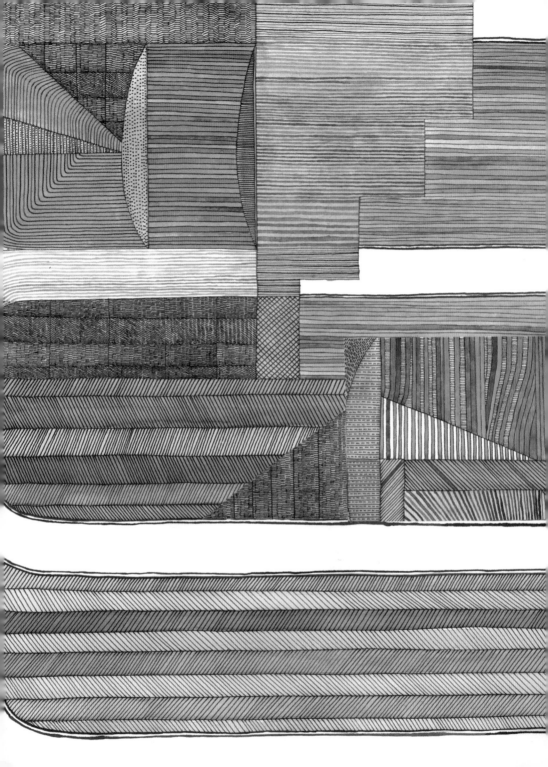

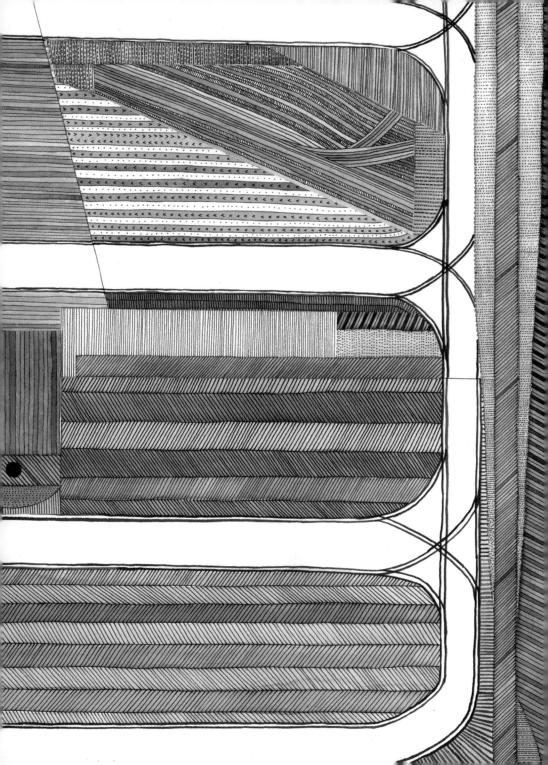

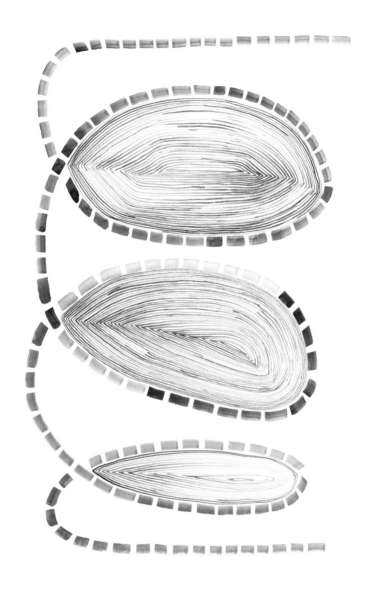

WHILE MECHANICAL LINES ARE PLOUGHED IN
THE FIELDS, THE SEAGULLS WHIRL ABOVE.

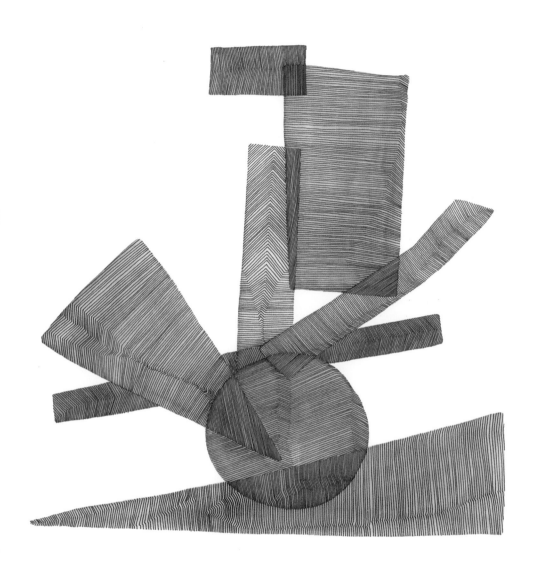

THE COMBINATION AND COLLISION OF LANDFORMS AND
COLORS IN THE FIELD

COLOR BANDS TRACE THE MOVEMENT
OF DIFFERENT ANIMALS THAT MOVE
ACROSS THE FIELD – ALONG, ACROSS,
AND BELOW.

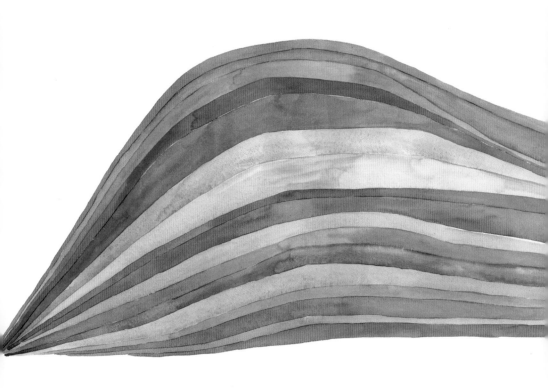

TEXTURES AND PATTERNS FOUND IN THE FIELD

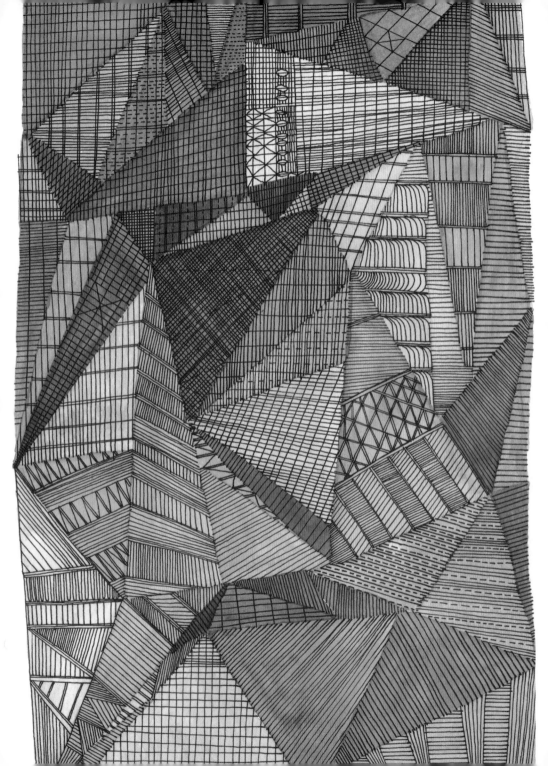

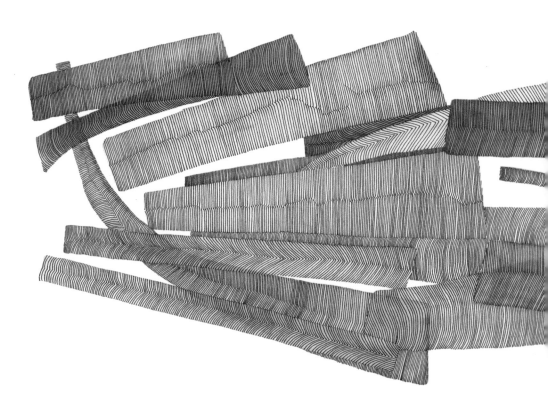

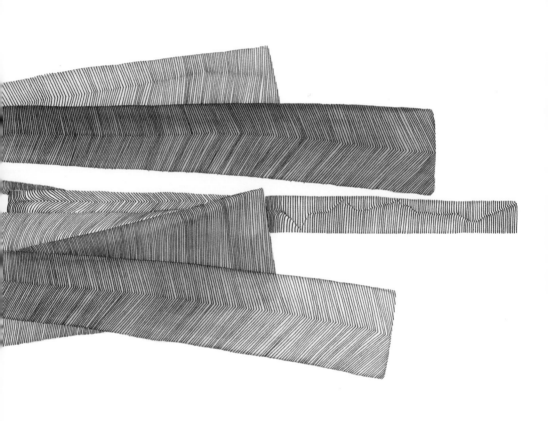

BIRDS MOVE ACROSS THE FIELD IN A
WHORL OF COLOR, LOSING AND GAINING
SPEED WITH EACH SNAP.

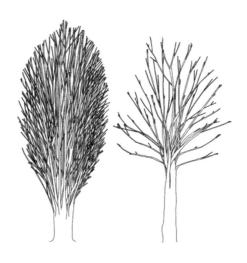

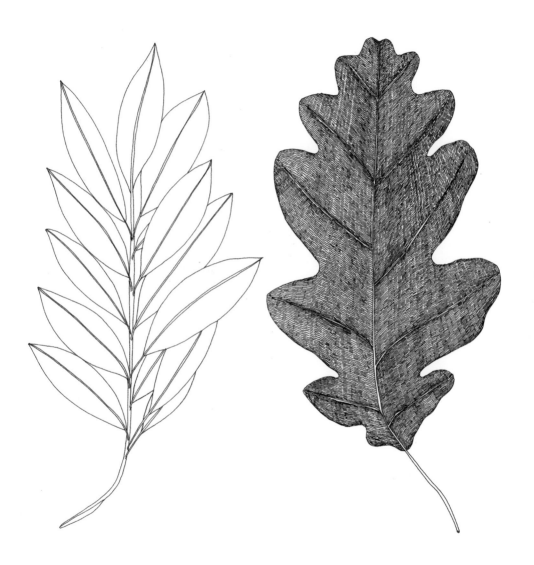

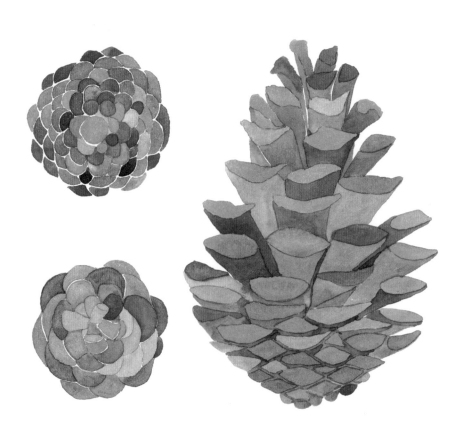

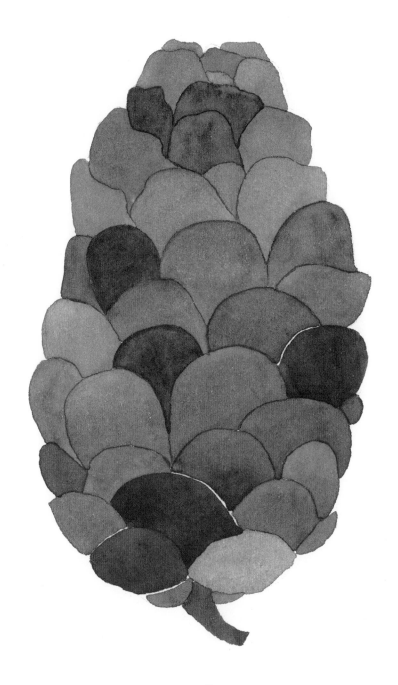

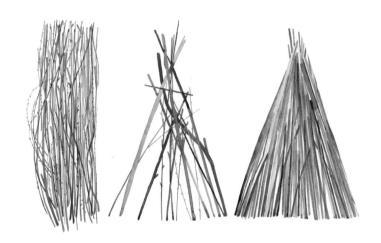

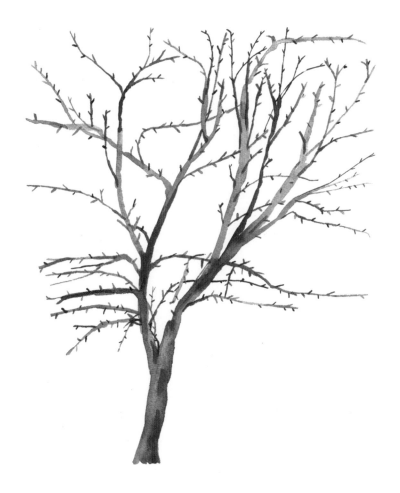

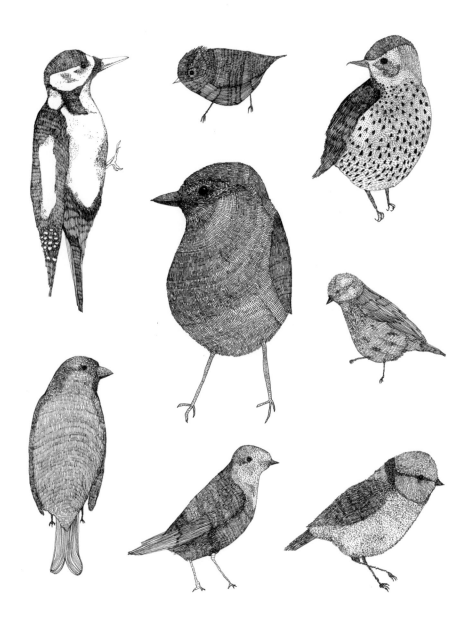

BIRDS' PATTERNS TRACE INVISIBLE LINES
IN THE SKY. THEY MOVE IN SWIFT,
IMPOSSIBLE ANGLES BUT NEVER TUMBLE
OR COLLAPSE.

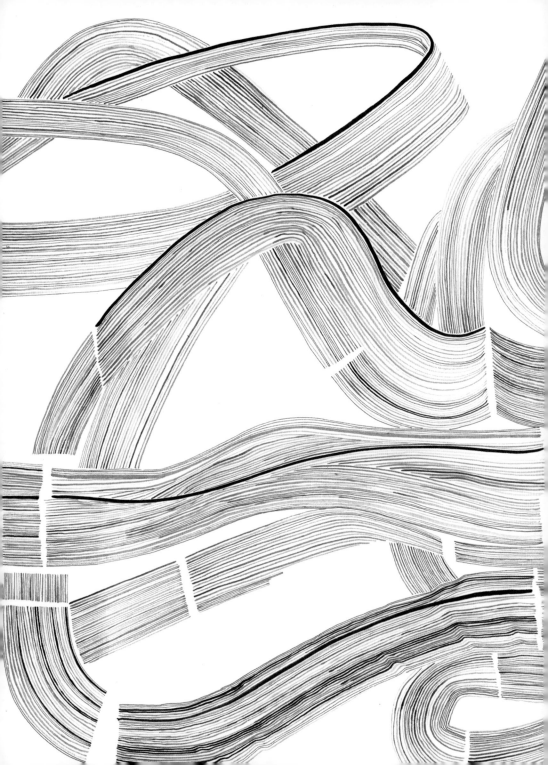

BLACKBIRD

CHAFFINCH

BIRDS, OFTEN
SMALL AND HIDDEN,
SING SONGS THAT
FOLLOW YOU
EVERYWHERE.

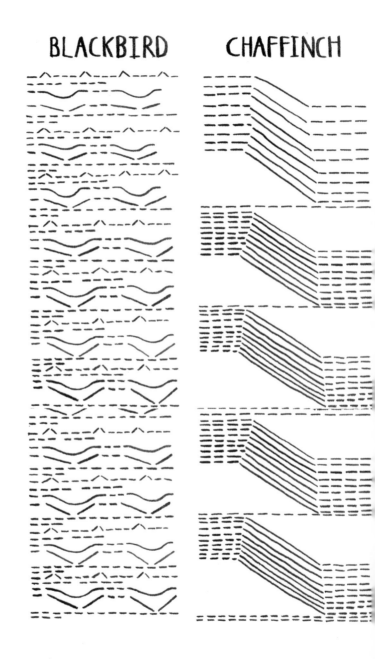

STARLING THRUSH ROBIN

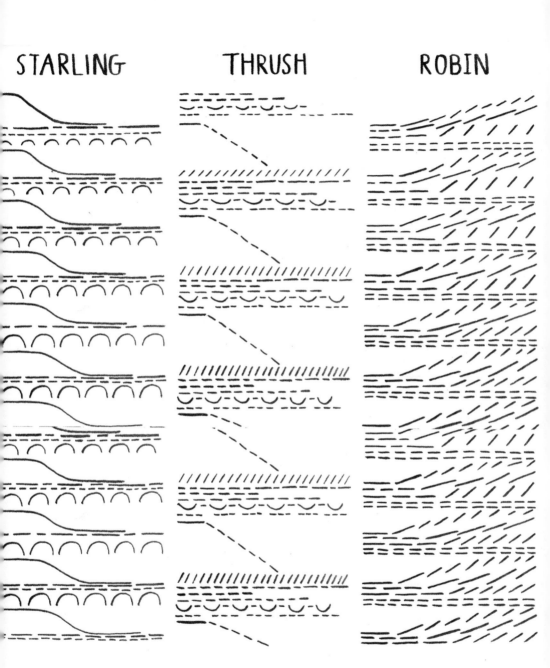

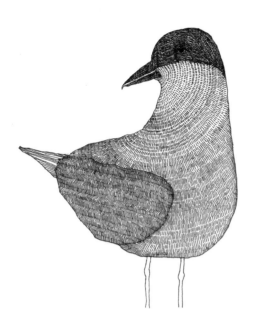

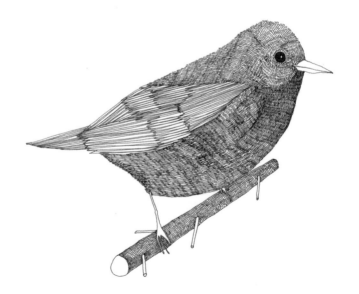

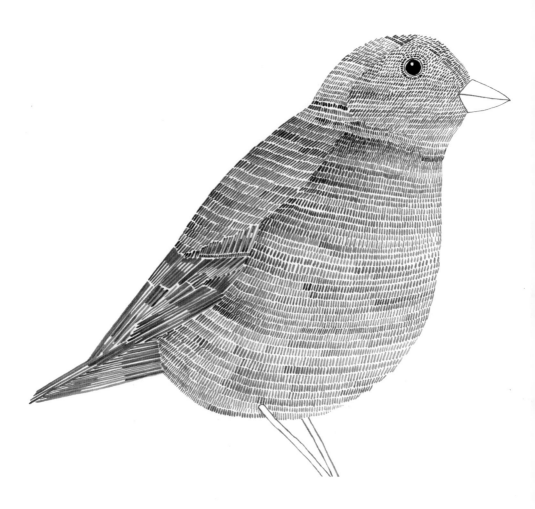

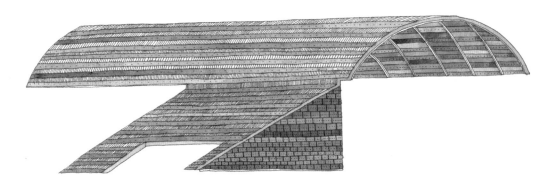

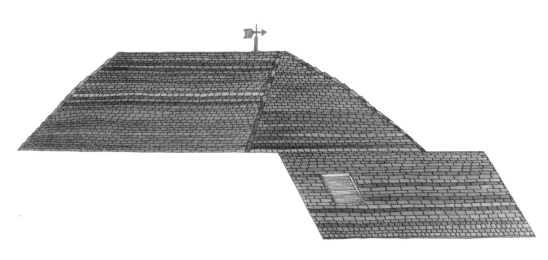

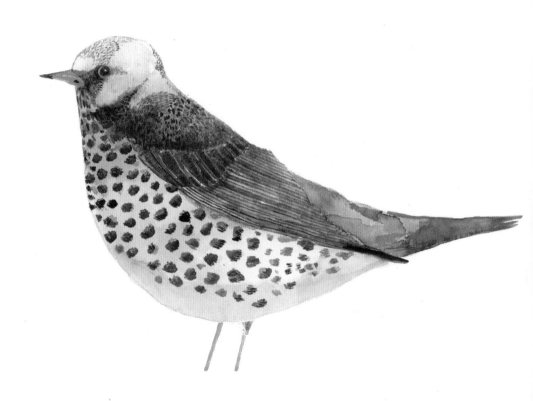

THE BIRDS' TRACKS CIRCLE THE TREE TRUNK.

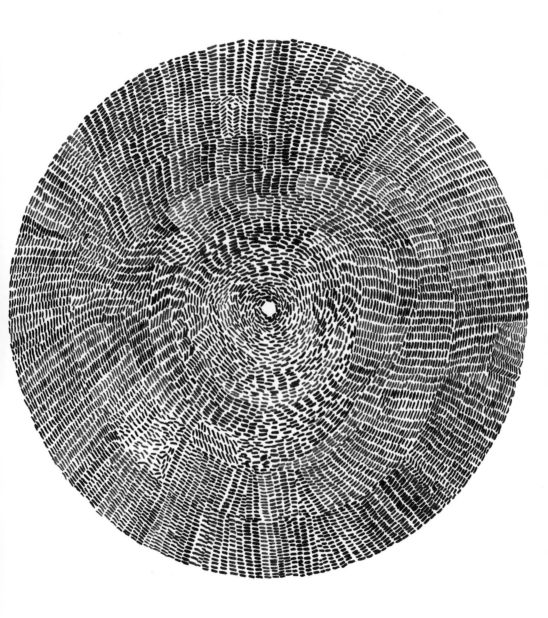

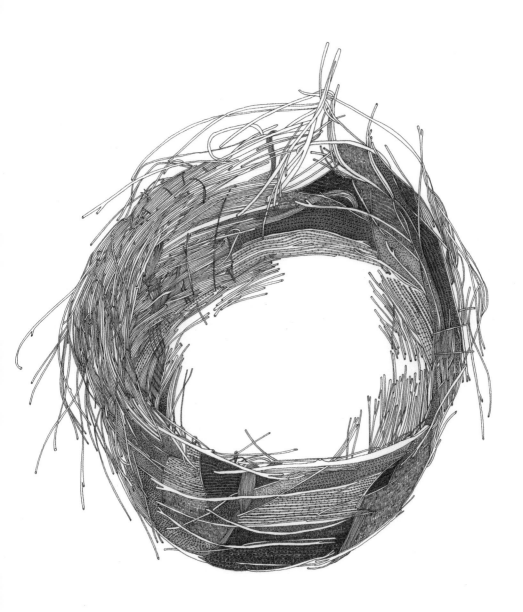

THE LAND
FROM
AFAR
AND
UP CLOSE

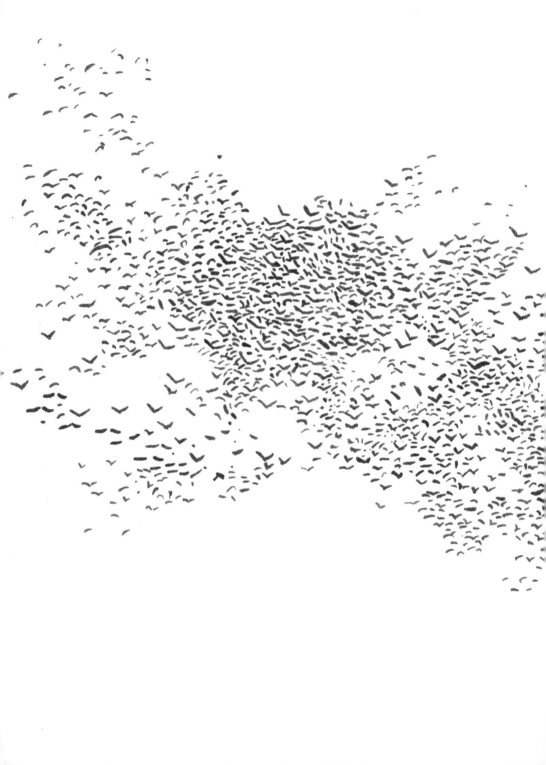

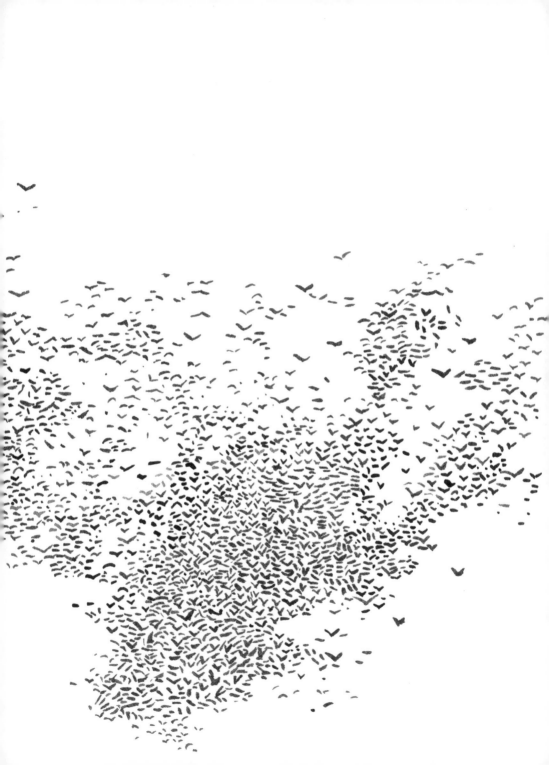

INSIDE THE FEATHER ARE FURTHER STRUCTURES.

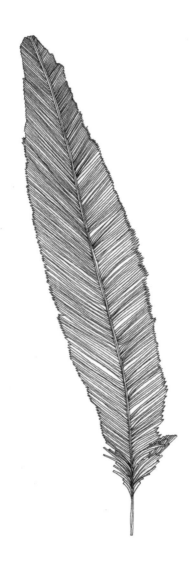

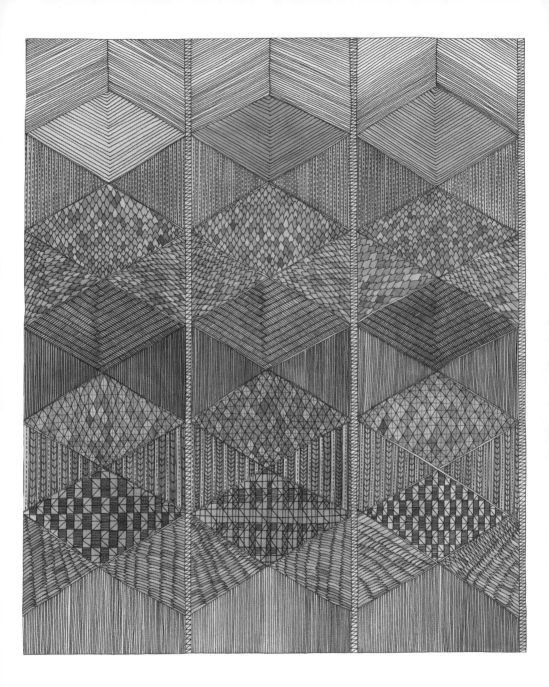

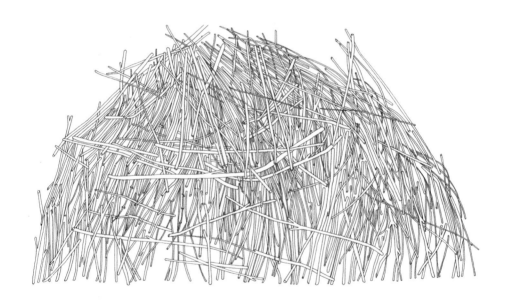

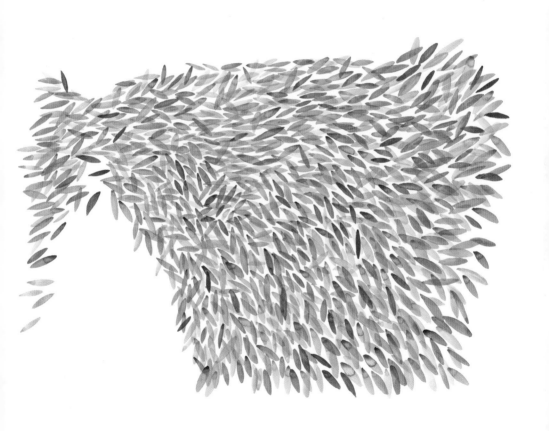

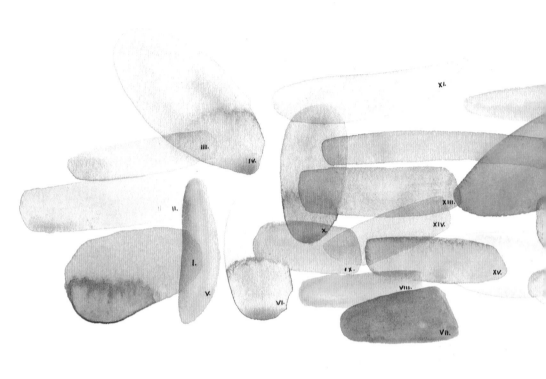

XXXV PLACES THE BIRDS GATHER

I. BARN ROOF (GREEN) 3.40 II. FIELD WITH THE TWO HORSES III. FIELD WITH A CONSTANT PUDDLE IV. EMPTY RED

VI. THE FOREST PLANTED BY THE OLD MAN VII. THE LANE WITH THE VIEW OF THE ISLAND VIII. THE SLOPED FIELD.

XIII. THE BAD CORNER XIV. THE FORGOTTEN TREE HOUSE XV. WHERE THEY PRACTISE MOTOR CROSS

CAVE. XXI. THE OPEN FIELD XXII. THE BLUE HILLS AND FIELD WITH A CROSS XXIII. THE YARD FULL OF

XXVII. PAST M's HOUSE AND INTO THE HILLS XXVIII. DOWN PAST THE TUNNELL OF TREES AND OLD OUT

XXXII. THE RED BARNS XXXIII. STONE SHELLS OF BUILDINGS XXXIV. THE OLD SUMMER

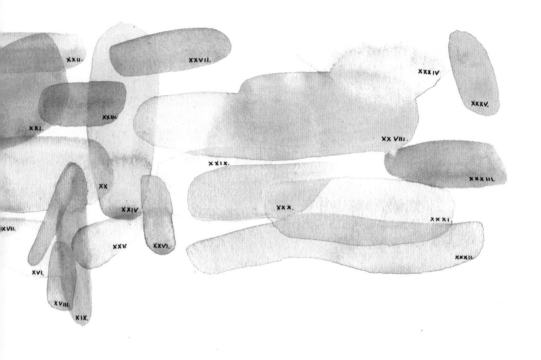

IN THE SECOND WEEK OF FEBRUARY

HOUSE WITH THE NARROW WILD GARDEN V. TOP OF THE ROAD CLOSE TO THE CORNER AND OPPOSITE THE FALLEN HEMMEL

IX. CREST OF THE HILL X. FIELD OF FALLEN BRANCHES XI. THE OLD TREES GATHER XII. LARGE FLAT FIELD

XVI. THE HIDDEN HOUSE XVII. THE NARROW. XVIII. THE FLOODED SWAMP XIX. THE ROCK XX. THE UNDERGROUND

DISCARDED EQUIPMENT XXIV. HOME AND OPPOSITE XXV. FAR TOWN XXVI. WHERE THE BON FIRE WAS

HOUSES XXIX. PLOUGHED LAND XXX. THE UPWARD SLOPED FIELD XXXI. THE CORNER OF THE ACCIDENT

HOME IN THE MIDDLE OF THE EMPTY FIELD XXXV. THE FALLEN FARMHOUSE AND YELLOW FIELDS.

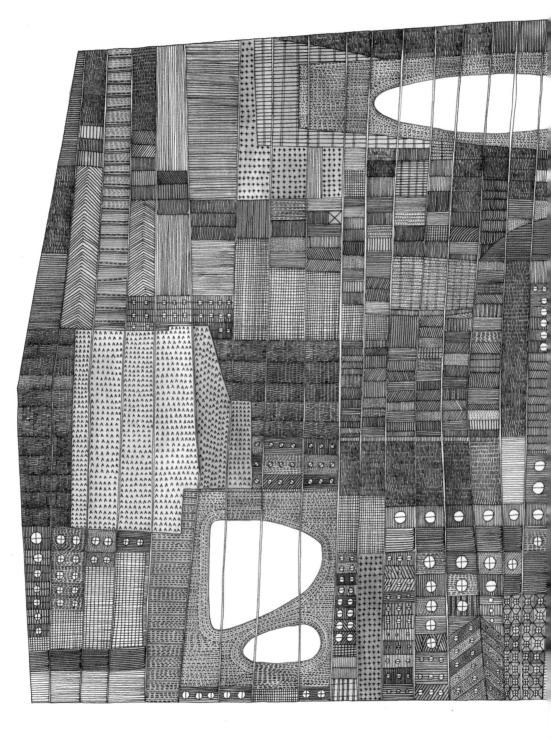

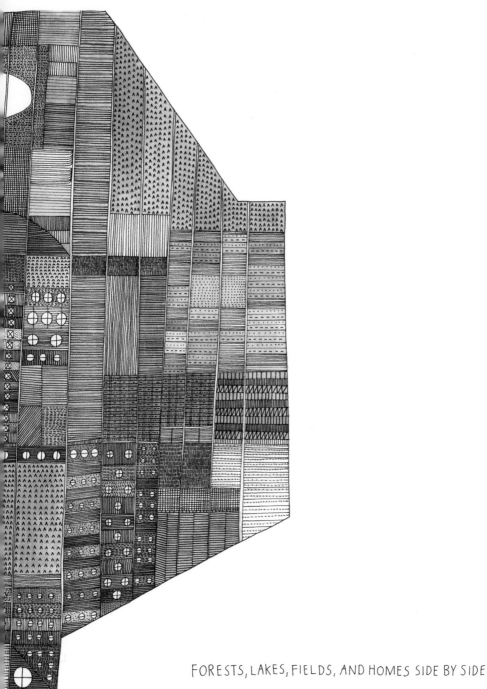

FORESTS, LAKES, FIELDS, AND HOMES SIDE BY SIDE

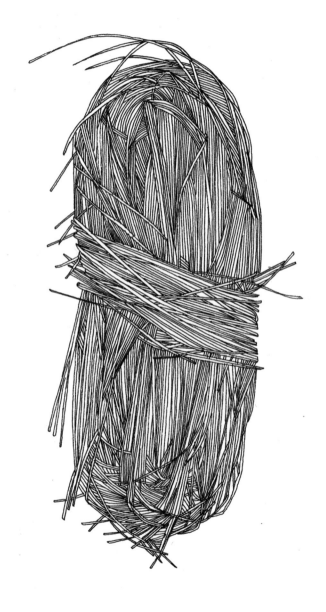

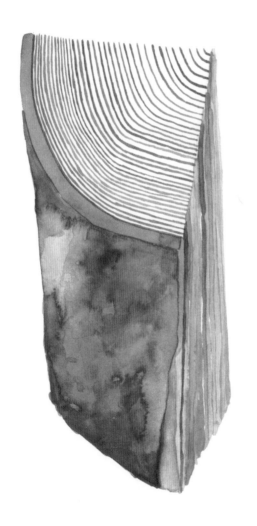

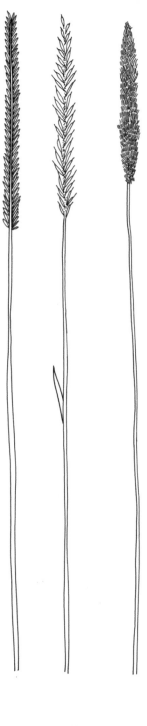

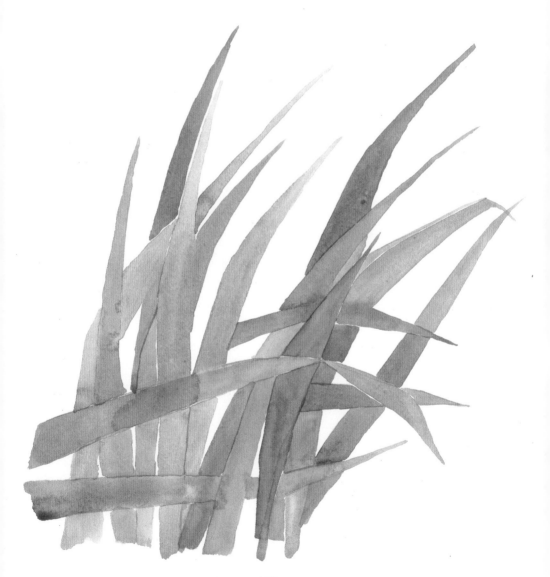

THE MOUNTAINS

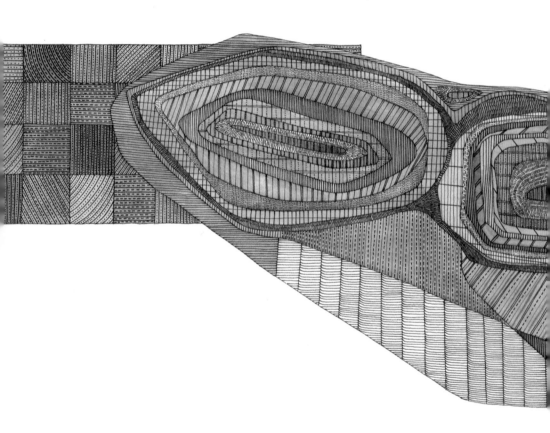

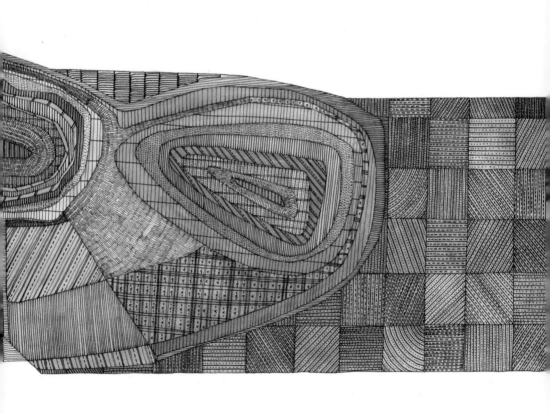

INTERRUPT THE LAND.

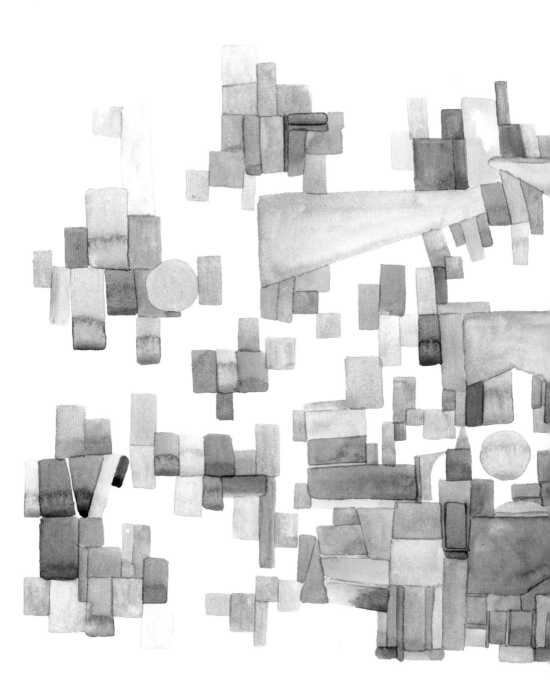

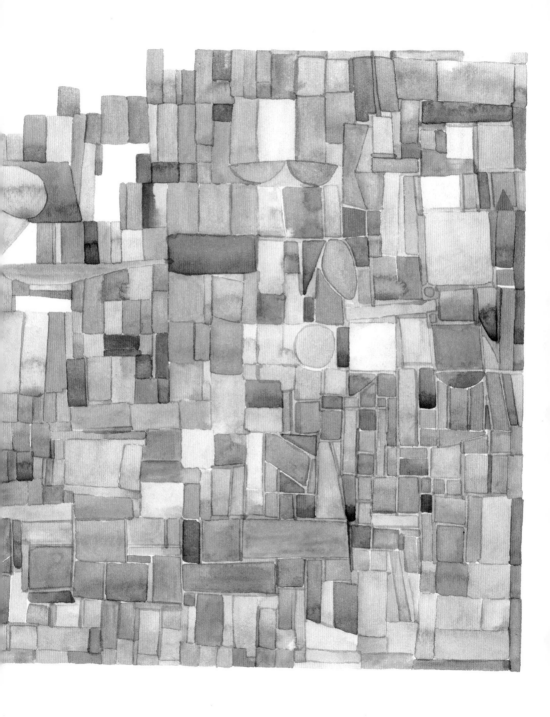

THANKYOU

THIS COLLECTION OF WORK WAS DRAWN DURING
A THREE-MONTH PERIOD IN THE WINTER OF 2009.
THANK YOU TO MY MOTHER, FATHER, BROTHERS, AND SISTER
FOR THEIR HELP AND KINDNESS ALONG THE WAY.
THANK YOU ALSO TO MY FRIENDS FOR THE CONVERSATIONS,
THE WANDERING WALKS, AND THE USE OF THEIR SOFAS.